For Kathy

Warmest [...]
for the body & the
spirit!

The HOUSE
the SPIRIT BUILDS

Poems by Lorna Crozier
Photography by Peter Coffman and Diane Laundy
Introduction by Rena Upitis

Lorna Crozier

Douglas & McIntyre

DOUGLAS AND MCINTYRE (2013) LTD.
P.O. Box 219, Madeira Park, BC, V0N 2H0
www.douglas-mcintyre.com

Edited by Silas White
Cover and text design by Diane Robertson
Printed and bound in Canada

DOUGLAS AND MCINTYRE (2013) LTD. acknowledges the
support of the Canada Council for the Arts, which last year
invested $153 million to bring the
arts to Canadians throughout the country.

Nous remercions le Conseil des arts du Canada de son soutien. L'an
dernier, le Conseil a investi 153 millions de dollars pour mettre de l'art
dans la vie des Canadiennes et des Canadiens de tout le pays.

We also gratefully acknowledge financial support from the
Government of Canada and from the Province of British
Columbia through the BC Arts Council and the Book
Publishing Tax Credit.

Library and Archives Canada Cataloguing in Publication
Title: The house the spirit builds / Lorna Crozier ;
[photography by] Peter Coffman, Diane Laundy ;
 [introduction by] Rena Upitis.
Names: Crozier, Lorna, 1948- author. | Coffman, Peter (Peter
Charles), 1961- photographer. |
 Laundy, Diane, 1960- photographer. | Upitis, Rena Brigit,
writer of introduction.
Identifiers: Canadiana (print) 20190133716 | Canadiana
(ebook) 20190134739 | ISBN 9781771622417
 (softcover) | ISBN 9781771622424 (HTML)
Classification: LCC PS8555.R72 H68 2019 | DDC C811/.54—
dc23

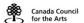 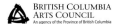

Dedication

Dedicated to the quiet grace and beauty of the land we
walk, to the Indigenous people who
nurtured this place before us and to those who will
continue to do so after we are gone.

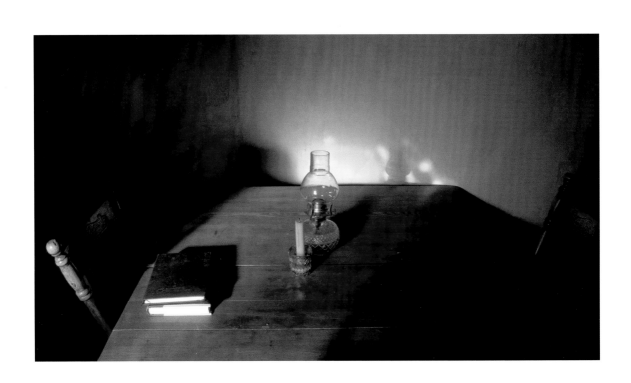

Table of Contents

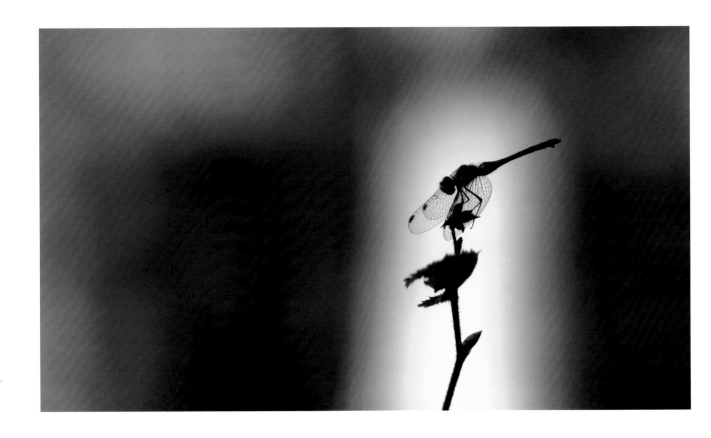

Acknowledgements

Our heartfelt thanks to Rena Upitis for her savvy, courage and love of the land that inspired her to create this place called Wintergreen. We also want to acknowledge the hundreds of volunteers who have documented the variety and richness of the life forms that survive here, many of them rare and endangered.

Thanks to D&M for believing in the project and to the thoughtful and creative people who brought this book to life.

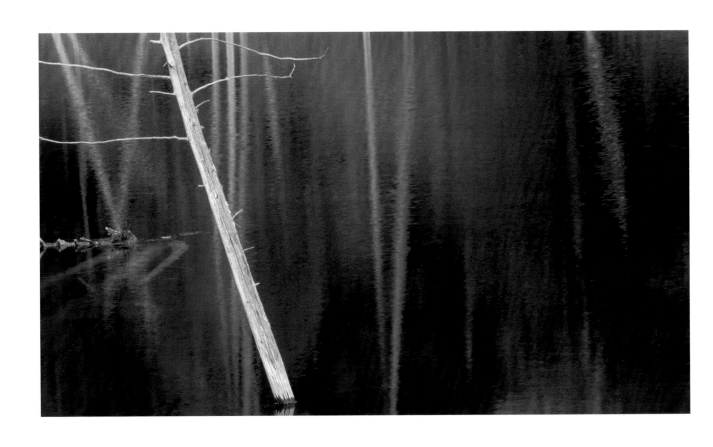

Introduction
THE HOUSE THE SPIRIT BUILDS

Three decades ago, I fell in love. On a Saturday morning in early April, I made my way through the dense brush of a mixed forest, guided by my compass and by the light of the sun. I came upon an open meadow where a few stalks of Timothy wheat waved a welcome. I took it as a sign that this land was meant for me. Not to own, but to cherish. Not to tame, but to learn from. For many years, I wandered alone or with friends and family through those forests to the lake, through marshes and meadows, coming to know the pulse of the place. The ways that the land changed with the seasons, and with it, the creatures and plants, which also showed their seasonal swings.

I developed rituals. I came to believe there was something sacred about this place. My desire to share this land with others deepened over time, just as my conviction of the importance of connecting with the natural world also grew stronger. Over the past ten years, this land has become a gathering place. Known now as Wintergreen, it flourishes as an educational retreat centre where people are nourished by the land, by the arts, and by one another. People's lives are made better by coming here.

Wintergreen is in the heart of the Frontenac Arch Biosphere Reserve, where our off-grid facilities are powered by the sun. The reserve is one of a global network of UNESCO designated reserves, natural regions with unique geographic features, populated with people committed to sustainable community development. The photographs and poems you are holding now were created by three artists who have spent many hours and days and weeks at Wintergreen, connecting to the

land that is part of the ancient granite spine of North America. They know it well. They love this place.

Wintergreen is more than the land alone. These artists are also intimate with the buildings and objects that are part of Wintergreen. The human-built dwellings have a dynamic presence here. Built with sustainable materials and using traditional techniques, including straw bale and cordwood construction with living roofs, the buildings have become part of the landscape. And the objects within these dwellings have a place here, too. The winter light splashing across the lace tablecloth. The pocket watch in the cordwood alcove. The shovel leaning against the golden wall of the garden. The porcelain teacups on the windowsill, passed down through generations. Humble objects that have been handled by human hands, many times over.

The beauties of Wintergreen, both outdoors and in, are often subtle ones. *The House the Spirit Builds* invokes a spectrum of responses to human-crafted and natural homes. While you might spot the occasional black bear at Wintergreen, you are much more likely to marvel at the nighttime calls of the barred owl or the impossible limbs of a praying mantis. Or you might pause "when the dragonfly lands and grips the skin / on the back of your hand."

And so, our book celebrates the precarious and delicate balancing act of living on earth. The small moments that make us gasp with pleasure—like the unmistakable sound of spring peepers waking from frozen hibernation and heralding the change of the season. Belly-clutching laughter over a drawn-out summer's lunch on the porch as we feast on produce from the garden. The quiet pause on an early spring morning when, despite all odds, the birds still sing.

We observe these wonders by developing a deep sense of connection to place, a connection that comes with time, patience, and extreme attentiveness. That attentiveness brings the realization that there is no such thing as the mundane and that we are surrounded by gifts that are easily overlooked in haste. The quest of

paying close attention—through words and images—transforms our relationship with place, wherever that place might be. The world stops being something to own, exploit, and plunder. Instead, it becomes a home to treasure and to savour. In these small traces, there is the promise of grace.

These poems and photographs, together, form a greater whole than as stand-alone art forms, powerful as they would still be, one without the other. The poems do not explain the photographs, nor do the photographs illustrate the poems. Rather, each takes sustenance from the other, asking us to re-examine our first impressions, to deepen our feelings, to take our understandings to a more visceral plane.

These three artists have captured much in their story of Wintergreen by being open to the teachings of place as they observed, listened, and created. If we are lucky, we will bring these offerings to bear on the steady undercurrent of our own lives, the day-to-day heartbeat of the ordinary. This book inspires us to pay attention to the peeling of an orange, the key that turns in the lock. To pay attention when "rain stops falling / but / hangs around / like the shape of lust / in bedsheets." Perhaps these subtleties—these spiritual acts—will help us better appreciate our place on earth.

The book closes with a plea to "pray for the white-footed mouse … Pray, / oh pray, for the snowshoe hare and the little brown bat." If we experience how these small particulars speak to the universal, we might yet learn to live in harmony with the home that supports us all.

Rena Upitis
Founding Director, Wintergreen Studios
November 2018

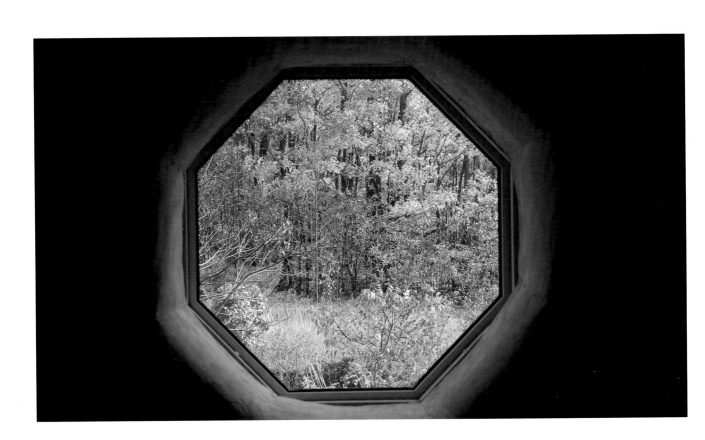

Ark

Crammed with two-by-two, it landed here, not Ararat,
startled the countryside that heaved it above the flood.

Most of the cargo—
except for spiders, a shy cat, a smattering of flies—
left the hold, went off to nest, to burrow, to dam,
to graze the meadows, to meander and multiply,
though some, quiet on their paws, return at night to the ark
that saved them. Under the porthole, they curl into pools
of midday heat the walls retain and then let fall.

While you sink in your bed under eiderdown,
they dream an eternity of clouds, as all around them
in the tidal waters of their sleep, still bob and drift
the drenched lunar faces of the drowned.

Nom de Plume

There's the sensitive fern, the fragile fern,
the interrupted. There's willow feather moss,
fire moss, whip broom moss.
There's poverty oat grass, fox sedge, field
hawkweed, coltsfoot, viper's bugloss.
And flickering above the seed heads there's
little sulphur, hoary elfin, northern
cloudywing, splendid palpita snout.
That's it. My old name's gone.
I'll only answer to *Splendid Palpita Snout*.
Ah, that's a mouthful! Then let's try
twelve-spotted skimmer, mudpuppy,
warbling vireo, rose.

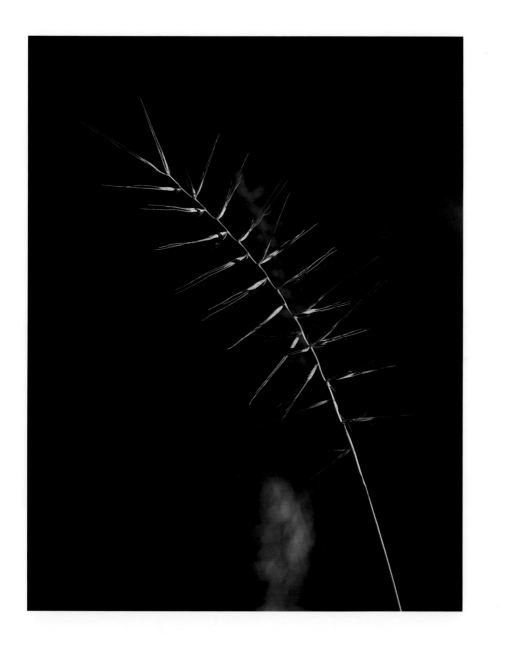

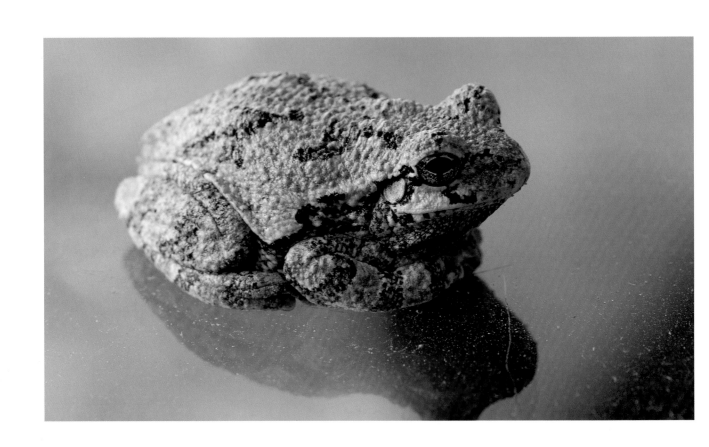

Toad

O, toad! So homely
you make me question all
I once found beautiful.

I'm small beside
your squat, rock-like
self-assurance, your

bumpy haiku-density.
Old master, old teacher,
belly round as Buddha's,

surely it's you
Issa wrote into being
two hundred years ago—

you look like
you could belch
a cloud!

Who Would Sit Here?

If wind needed a place to rest,
to while away the afternoon,

it would choose this chair.

The brittle slats can't hold anything
much heavier, and anyway

the chair's half made
from strips of air, of gaps and

hesitations

as if the one who built it
had been the wind's apprentice,

an old-style country artisan
who bent and shaped

his own breath
into a kind of mortal wood.

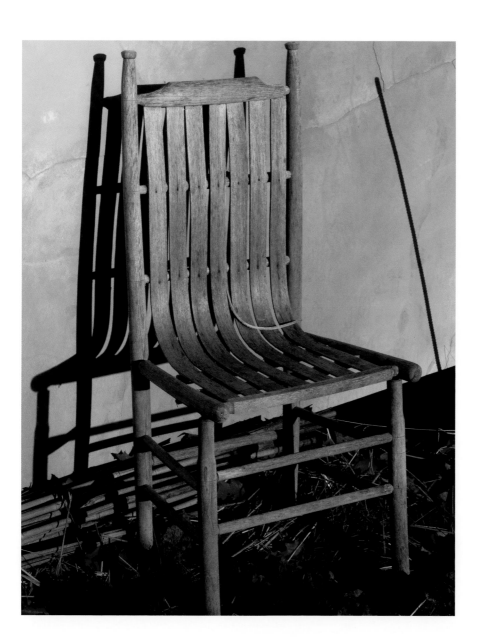

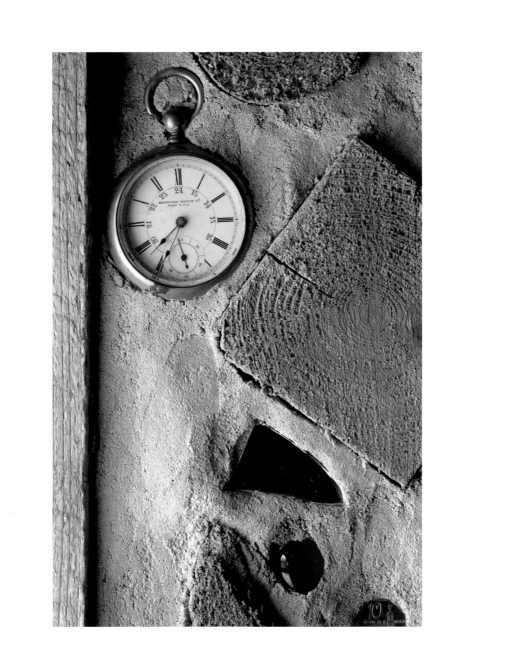

Tick, Tick, Tick

If you could take apart the stones in the wall
you wouldn't see gears and wheels—their inner apparatus

more delicate and small than the innards
of the finest watch, even a jeweller's loupe won't bring

their workings closer to your eye, yet you know
stones are time's familiars, resemble clocks and watches

more than any other human thing. Minute by minute,
hour by hour, become centuries in a stone,

galactic years, eons. Hold one to your ear:
you won't hear the sound it makes

but the earth does where the stone once lay,
its slow, invisible hands

moving closer to midnight.

Teacups on Windowsill

They've given up
on tea. Now it is light
they want to hold, the sun

as mother, pouring
into them morning's
golden lumens.

Drink this, the sun says
though it knows
you cannot hear.

When you raise the cup
to your lips, what happens
to your tongue, the dark

cave of your mouth?
What happens to your throat,
its slow, blue pulse,

as the light slides down?

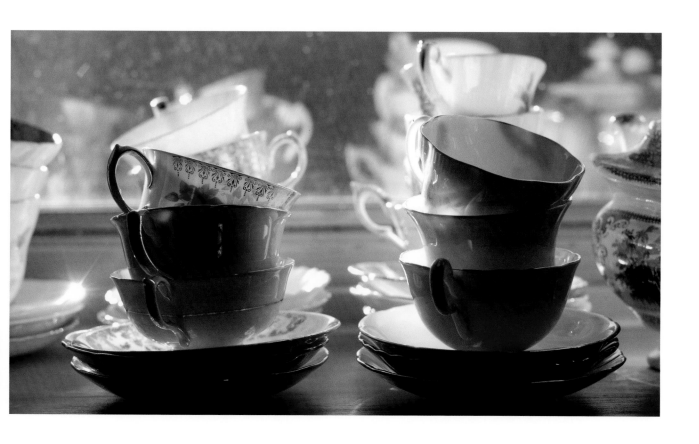

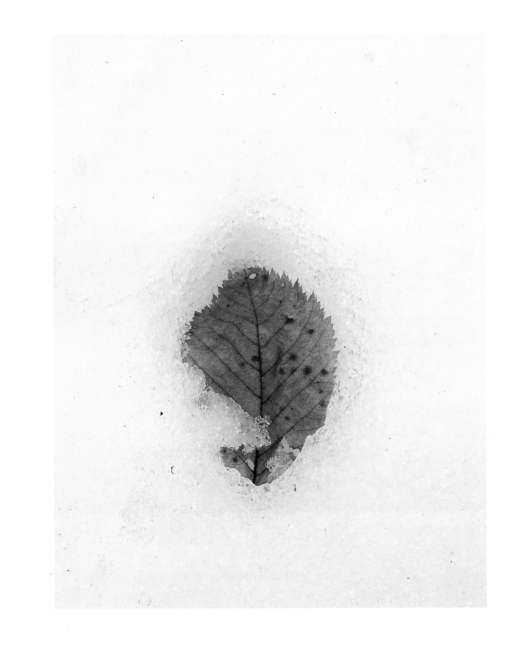

Photographer

Who's behind the photograph,
who's chosen to disappear?

What if it were a bear,
the shutter mechanism
adjusted to accommodate
that big paw?

Camera banging on your chest,
you know the ones you look for
watch you as you walk the paths,
though there are better things
for them to pay attention to—

curlicues of grass, for instance, as beautiful
as scripts in Arabic, the black fur
edging a brown hare's ears,
even this leaf

on a canvas of gritty snow.
(It's like an epitaph,
a mourning card that doesn't need
the sorrow of a word.) A tree could've
taken that: check out the titles
in its thin, viridian portfolio:
Leaf 1, Leaf 2, Leaves 3.

The Sun's Handiwork

Across the tablecloth, the sun weaves another
out of light and lace. If it persists, even
for an hour, you'll wear it as a veil
to meet a ghostly bridegroom;
you'll wind its threads around a child
born only in a dream, his small head
damp and blue.

You'll drape it on the hands
of your mother, dead these fifteen years,
so her bones can finger the sun's
quick handiwork and move in memory
through all the tasks they used to do
to give a hard life, however
fleeting, a touch of grace.

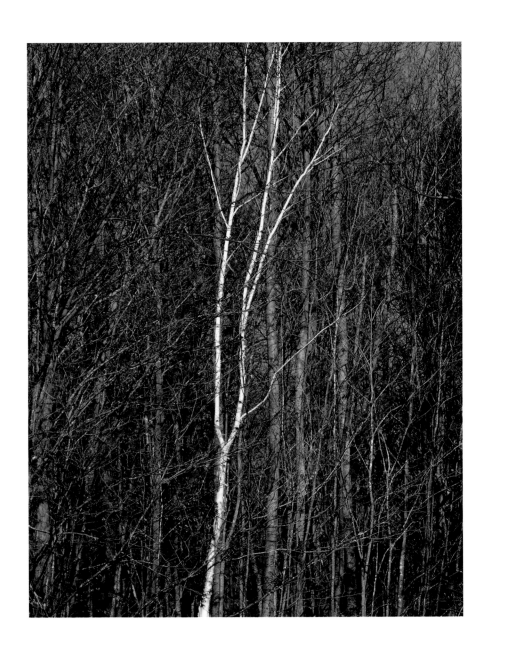

Spirit Tree

It's the tree
the stars find first
(what would nest there?)

the one the child in you
dreams
of climbing

branches so thin
perhaps you're not

a child yet

but something smaller than
a smoky shrew

lighter than an eyelid
on a feathered eye.

Blessing

Its *is*-ness,
the inner spark
that makes it grass—
not twig, or word, or feather—

leaps from inside
and ignites
the seed head.

Nothing you know
of rain, of grief,
of darkness
can put it out.

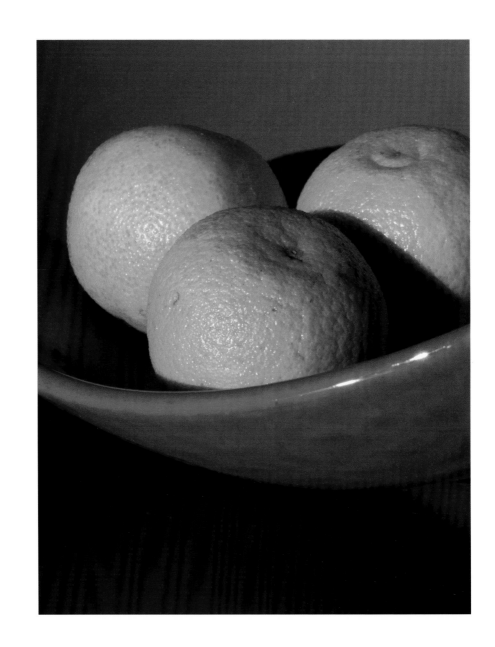

Three Oranges in a Red Bowl

Three oranges in a red bowl—and suddenly
you're in the south of Italy, the sun cupping your bare shoulders
as it does the fruit, the round and ripe of them. You're young,
you're in love, so noisy in bed the night before
the man in the next room shouted, *Silenzio! Silenzio!*
and you snuck out the door in the early morning, afraid
to meet him in the breakfast room, but the boy you spent the night with
(you say *boy* though you were both nineteen)
walked tall and proud past all the tables, the buttons of his shirt
undone. The dress you bought later in the Piazza Trieste e Trento,
wasn't it the same deep red? And the lipstick that made your mouth
Sophia Loren's. That summer day, nothing around you was about to end,
though riding on the handlebars to meet his mother, you knew
by fall it would be over. She did, too. That's why
she was kind, touched your face, and called you *bella mia*.
That's why the wineglasses on the kitchen shelf caught
what briefly glowed inside you and showed it to the world.
At the wooden table the woman who was his mother chose an orange
and rolled it in a circle under her palm. *To make it sweeter*, she told you.
Succoso, he said, *succoso*, as he split the peel with his long thumbs
and placed the segments, one and then
another, between your lips.

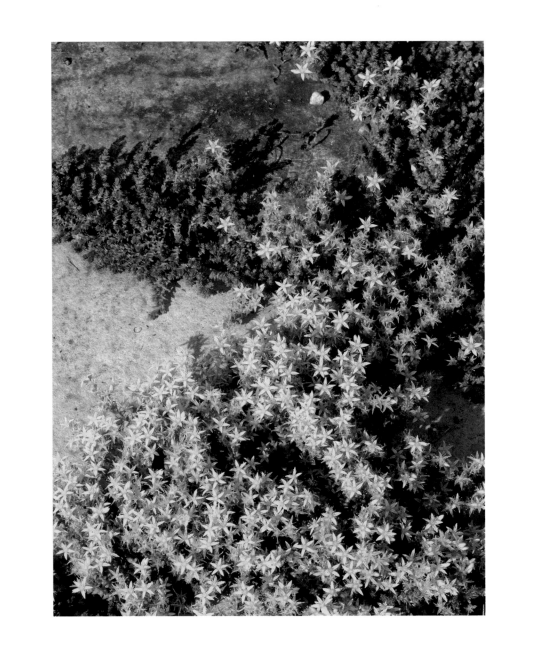

Star Cluster

Astronomers abandon
their telescopes,
look down
instead of up,

calculate the mass,
the metallicity,
and where
the gap is

in the galaxy
(*what* galaxy?)
now that an entire
constellation

has fallen from the sky
choosing,
over heaven,
this common patch of earth.

Key 1

You're tempted to keep it
tightly sealed
in a tall jar with holes
punched in the lid.

Perhaps it is not a key
but a long-thoraxed
praying mantis
about to grow legs
and walk away.

Key 2

Is it called skeleton
because it unlocks the mystery

of bones

opens the door
to ever-after?

Be careful
how you use it then,
and who you give it to.

And remember a door
may not be your idea
 of *door*.

It may be made of birds,
of rivers, of rock salt.

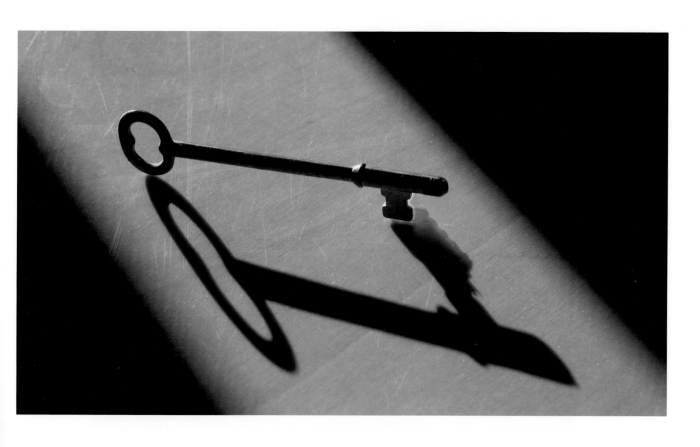

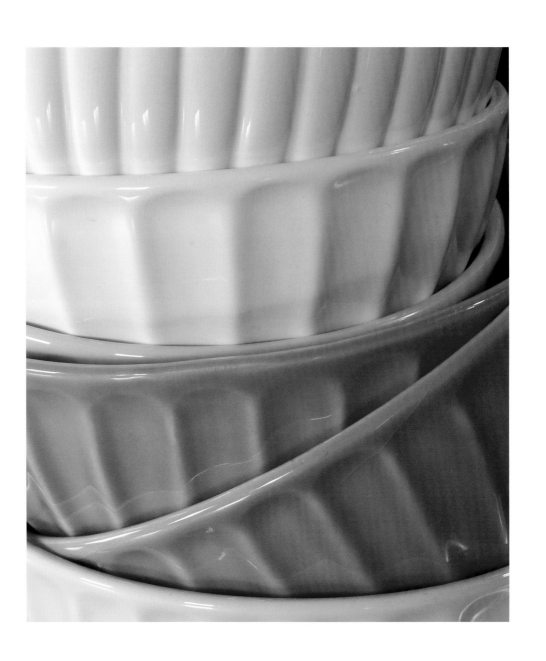

Fit

It's not only bowls
or tautological
arguments that fit
one inside the other, it's you
in me and vice versa, it's
who I was and who I'll be
tomorrow, it's afternoon
sinking almost
into evening, it's the ring
inside the ring
inside the tree, light living
inside running water
and in the eye.
It's that bigger eye,
all of us holding
one another, no matter
what the sorrow,
what the loss.

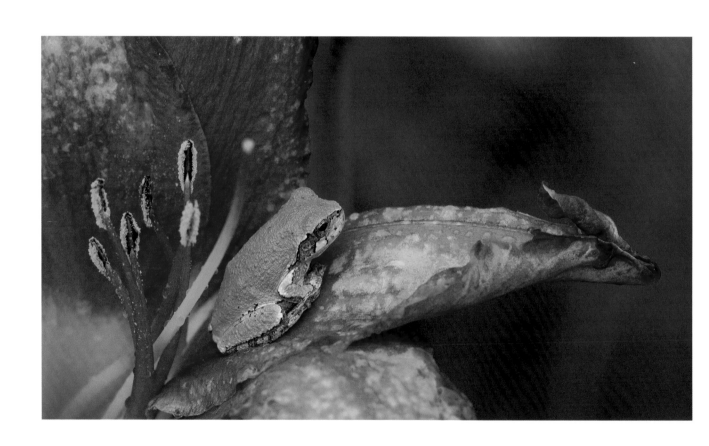

Mating Song

If the lily had ears to hear
it would be happy—it has

a rain-splashed throat,
crimson and longer than a frog's,

but on its own
it cannot sing.

Sometimes a Woman

Sometimes a woman wants
not to be a woman. There are needles
on the tallest pines, numerous, ubiquitous, touched only
by wings, the weather and the wind.
There are ripples over stones, yet they remain stones
giving off a watery gleam; there is ice, broken and whole.
The ground she lies upon takes her weight and sinks
a little. She has never been more alone, more
beautiful, her many years merely now a listening, a breath
among the other breaths, a humming inside the earth's
loamy compositions, a small dry haunting
among the many fallen leaves.

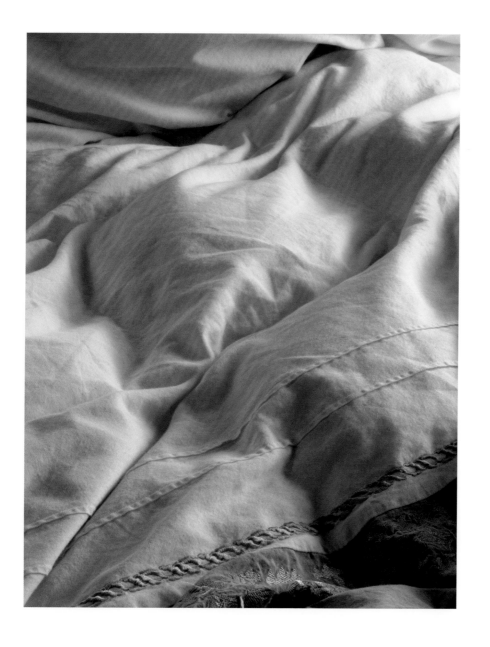

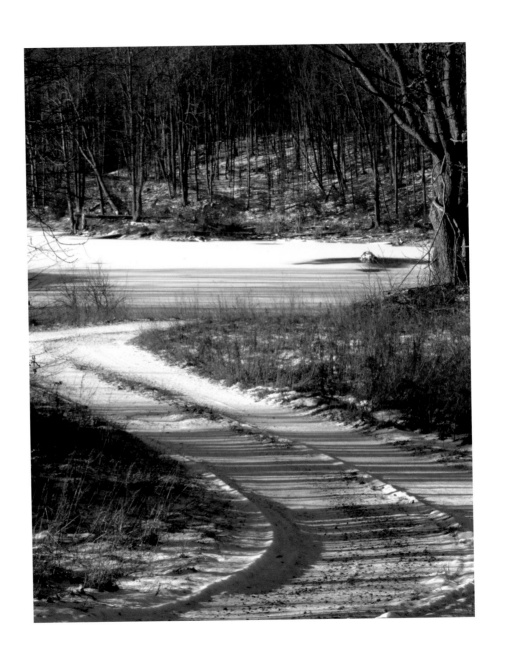

In the Country

When is a road
not a road? You don't mean
metaphor. You mean

here as it turns a corner
you can't see past,
the tall trees leaning in.

Why do you believe
it's a road you'll find
around the bend?

Why not a skein of salmon,
the fishy gleam of them
ravelling upstream, the gravel

a perfect spawning bed (oh, watch
the land-gulls gather), why not
a sack of letters

plopped in the middle
like a soft boulder
stopping the to-and-fro

and you've been chosen
to deliver them tree to tree
although the avenues

of birch and maple
bear no names or numbers
visible to the eye?

Why not the low, full moon
you come upon around the bend—
you sense it mulling over

everything it shines on—
as it builds a big-hoofed,
white horse

from the ground
up.

What Does It Mean to Be Open?

A buck lowers his antlers
and looks through the screen
at the bed where you sleep.

Your head on the pillow's
a mystery to him.

A black fox steps into the clearing
where you sit on a rock,
book in hand. She stands
so still your heart stalls, too.

She's never come upon anything
like you before.

Deep in the trees
a door swings on hinges—you thought
it was branches creaking in the wind—
and light strides toward you.

Everywhere in this place
you've come to be alone,
something sees you.

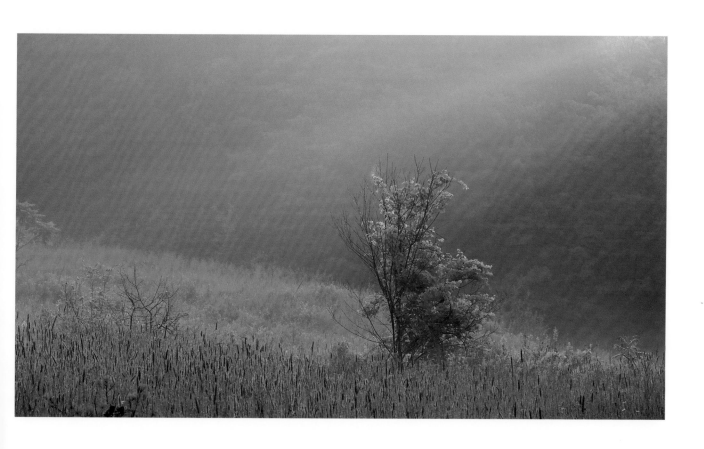

Change the World

An exquisite jewel
a goldsmith designed:
the glamour of its long
gilded waist, the delicate
mechanics of hover and fly, all that
fretwork in the wings. There,
the thinnest lenses,
shattered, reassembled,
fused together,

now stop
the light
a nanosecond
then let it
through.

When the dragonfly lands and grips the skin
on the back of your hand
with an exact weight-
lessness specific to its kind,
you know it's too alive to be
a man-made thing,
too glis, glis, glistened and fierce—

it holds you in its eyes
like no other—sixty thousand facets
shrink and multiply your face.

Even for a moment
before it flies away,
think of all the splendid things
this myriad of you can do.

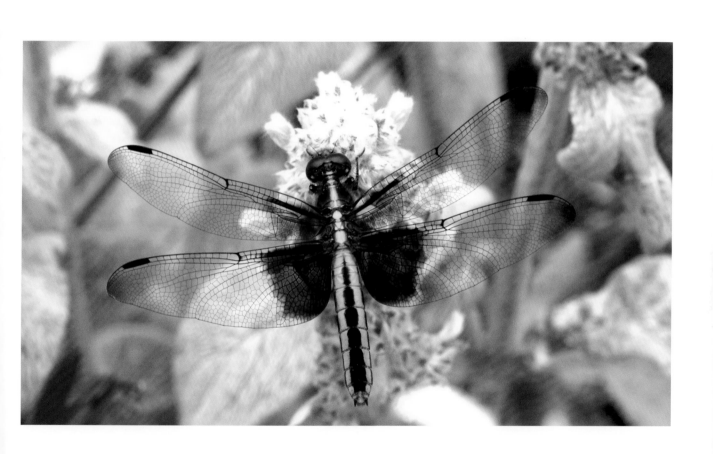

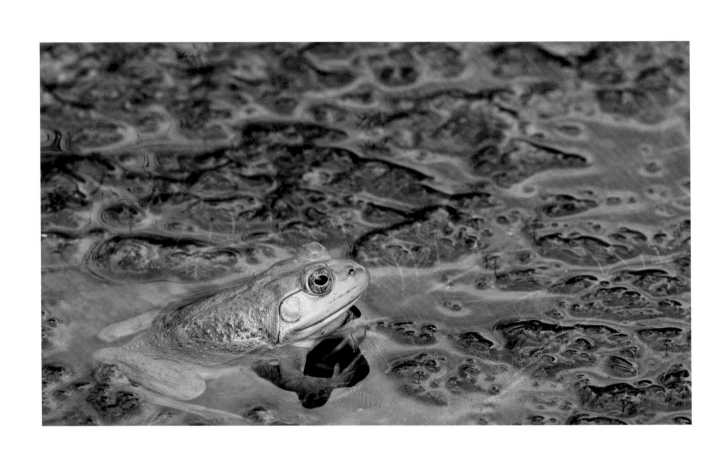

Frog

He props his chin
on an orb of music,
thin-membraned, translucent,
more mysterious than
any planet.

You're drawn to the pond
by his song, so much bigger
than his body
the size of your thumb,

and you want to kiss him—

Not sick of being frog as you're
often sick of being human,
he'll stay the same
but what will you become?

And will you miss the things
he doesn't need: your violin,
your summer reading,
your sleek canoe?

Black Bug

Into the treacherous unknown
he sent the beetle forth.
A tiny, armoured robot,
click, click, click, it stuttered
through the dark on hard black feet,
infiltrated every corner.

Done for the day, the spymaster slid
like an ordinary man between the sheets,
his helmet with its mask propped
on the bedside table. (*Death's head!*
you'd have cried
if unaware you'd come upon it
and you'd flee.) More frightening

is the face, the right side
not pressed into the pillow, the ear
no one's seen in years, naked and listening
for the small familiar to return,
to scratch its findings in the dust
along the windowsill: what goodness

has survived out there and where
it's hidden, what forgiveness, what ragged
scraps of joy.

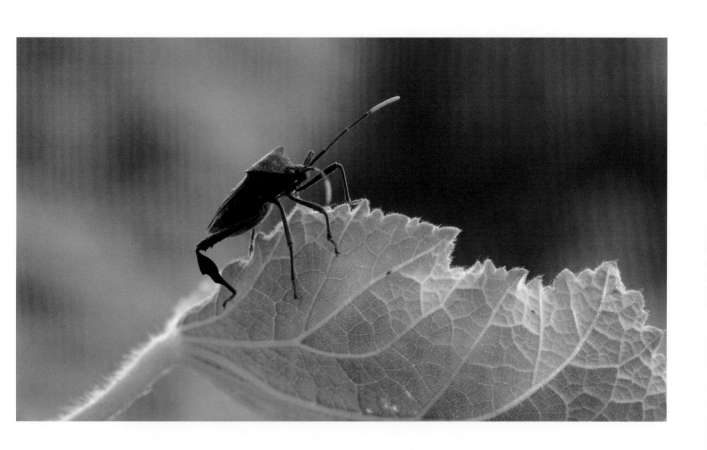

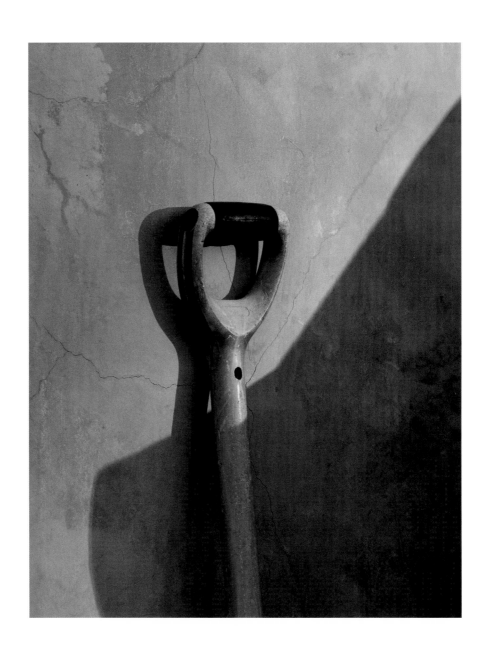

Is Every Poem an Elegy?

As the mouth
suggests a mouth, the heart
another heartbeat, so

the handle of the shovel
suggests a hand.
There's a patience

in its lean
against the yellow wall,
an expectation.

(Where is the gardener
so careful with her tools—
called to the city, gone for a nap?)

You can't help but hope
it's a garden bed, not
a grave needing to be dug,

the spring-awakened
blameless earth
waiting to be turned.

Sunflowers

Did the seed packet warn
they'd grow this tall?
Giraffe of flowers, they reach
the windows—are they looking in?

Lucky for you
no matter what you're up to
in your private room
they've stared too long
at the sun (they didn't heed
your mother's warning,
they can't give anything away.)

All they do all day is tip
their faces, bigger than
the biggest barn cat's,
to the sky
and see nothing
but.

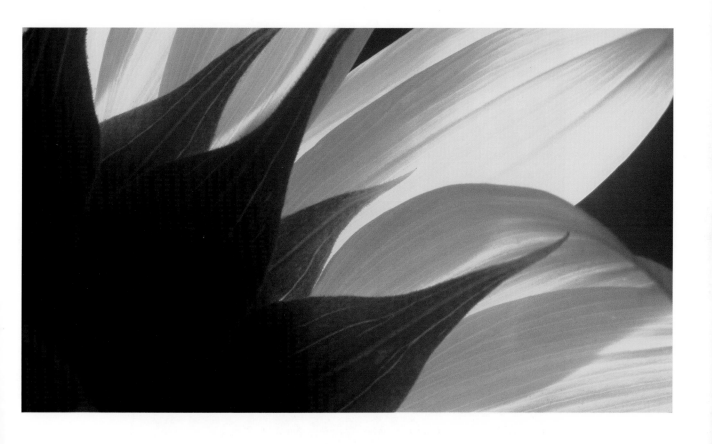

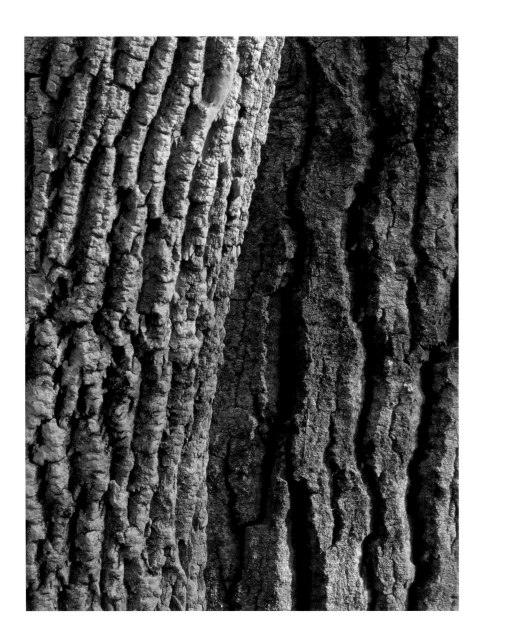

Big-Toothed Aspen

Don't mess with this tree!

It masticates the wind,
bites the blue
then hawks it out.

Chicken Little got it right.

Pieces of sky, chewed up,
spit-drenched,
are falling on our heads.

Most days we call it rain.

Teachings of Water

When it's half-
way to being ice, water
is neither.

It doesn't have
a body or a name.

You too, frost in your hair,
can be like that—

anonymous and
in between.

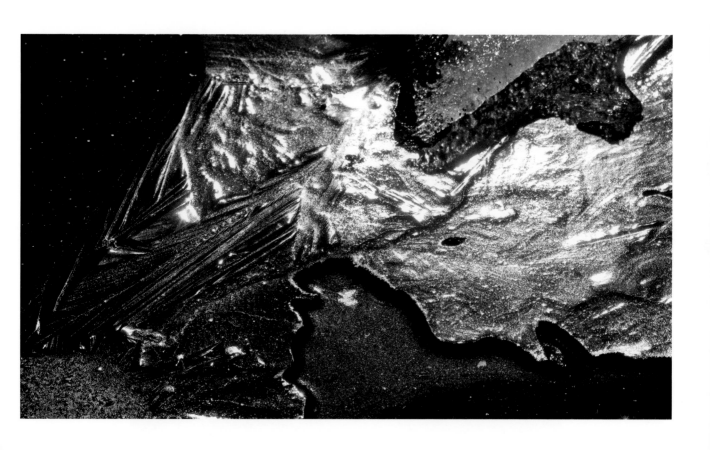

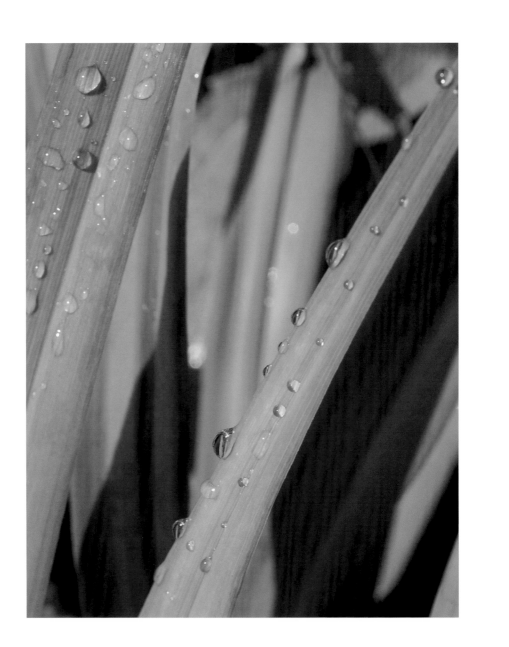

Drop

Rain stops falling
 but
hangs around

like the shape of lust
in bedsheets, the flavour
in a slice of

lime; you imagine the
pucker, the bedroom
funk, the drop

caught in
an eternity of now
before an insect

alights on
the stem
and sips.

Not Giverny, But

These leaves conjure Monet:
float in the canvas of the pond
and enter a painting

about to be discovered
in a garden shed,
rolled up between mildewed sheets
that once shrouded plants
during nights of frost

in Giverny. It's easy to imagine
Monet at eighty-six, just before he died,
staring from his bed
at what would be the end

of the *Water Lilies*, waiting
for these last dabs of red
to dry.

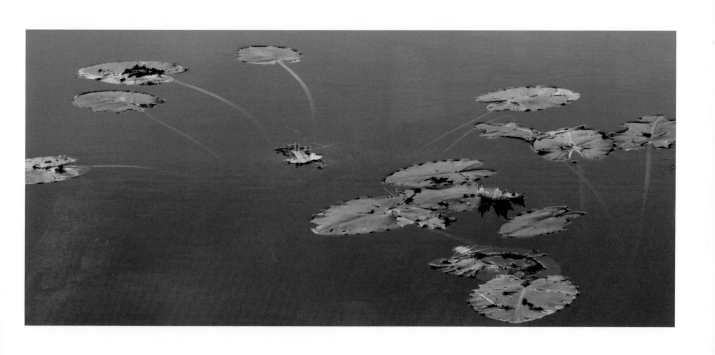

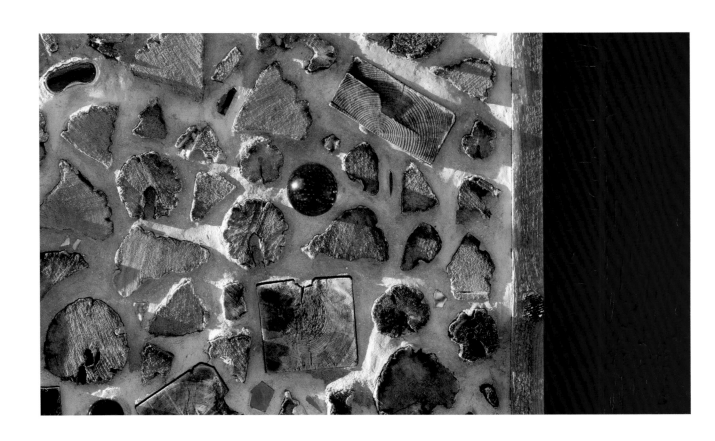

Things Are Not What They Seem

Check out the worm (is it a worm?—
no, it's a millipede!) that looks
like a rusted spike. Long enough to hold
a couple of two-by-fours together.

Easy to imagine it in a builder's
leather pouch, in a bucket in a shed.
Easy to see it as one of many nails
a boy was told to pull from a board.

He yanked it out, it fell in the dirt and crawled away.
What did he think, that boy? *Things are not*
what they seem? Did the millipede's mimicry
turn him, years later, into a hat-and-rabbit

magician, a grifter, a soft-hearted carpenter
who delights in dovetail, tongue and groove;
who builds walls out of bottles, mortar, cordwood,
broken watches, crockery—and never has to kill a nail?

Breakage

At three a.m. a shattering and you fear
something inside you has broken.

When you walk into the kitchen hours later
you see the salt shaker's
busted (was a pin pulled from the top?), crystals exploding

on the table—a spill of damage and bad luck.
Someone has carried off most of it.
If the grains had been sweet, you'd arrest the ants.

You toss what's left over one shoulder, then the other,
not remembering which side's the curse, which the cure.
No one sees you are not the same; no one sees

you've been ruined. Salt in a wound
helps the healing: that's another saying
you should heed. Did the moon last night

slide its bovine tongue across the table, across the part of you
that's damaged? O, how the moon longs
for the ocean, how it loves the taste of salt

on anyone's hurt skin.

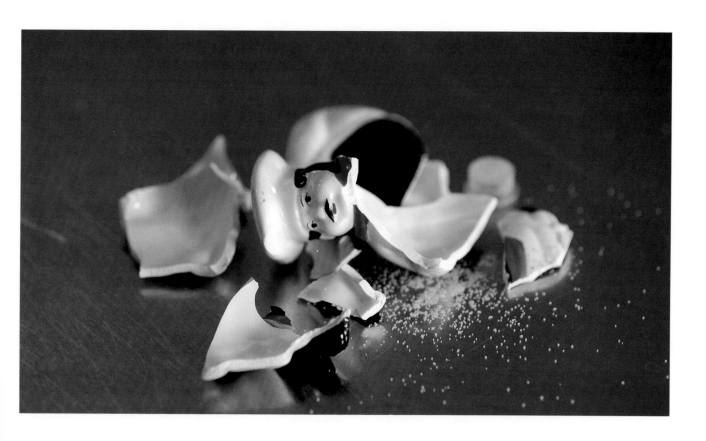

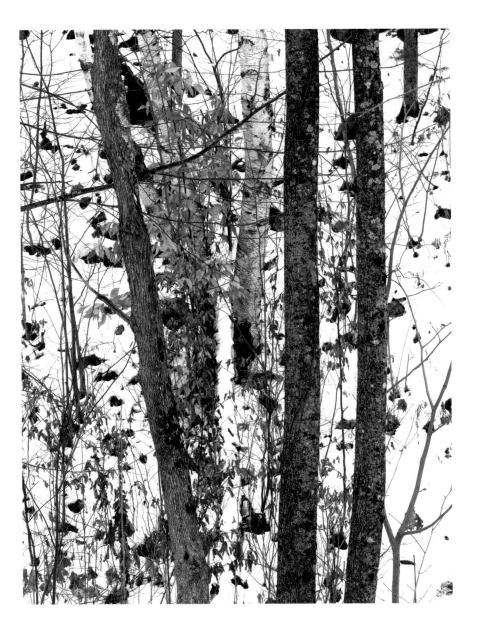

Snowfall

(treatise for the professor of the history of architecture)

In the woods you snowshoe through,
just before the pond and boulders,
there's a log
porcupine motel.

How could the builder have been so dumb?

Of course the porcupines have chewed the walls—
there's almost nothing
left, just a ghostly shape
you glimpse at twilight,
though the dog gets it
on every trek, barks and growls
around what's gone, his pawprints
blueprints in the drifts.

The spikey rodents' tails and claws
have worn away
the rooms' dingy rugs—the same
browns as the paths in fall—

and what was on the screens
of those budget black-and-white TVs
now is wordless,
after midnight, ever-falling snow.

Camera Questions

The great horned owl disdains
 the camera. With a gaze like that,
who needs it?

How can anything
without ears,
the owl might ask,

hear the rustle beneath
the leaves and snow
and capture—

in two wingbeats—
that
stunned heart?

And what can a camera,
with its long
promiscuous eye, expect-

orate that can compare
to the owl's compact
packets, the fur

bones, claws and teeth
of chipmunk, rat or mole,
their once-alive

put-togetherness
now jumbled up
out of whack

but as immortal, surely,
as any photograph,
which is fleshless, too?

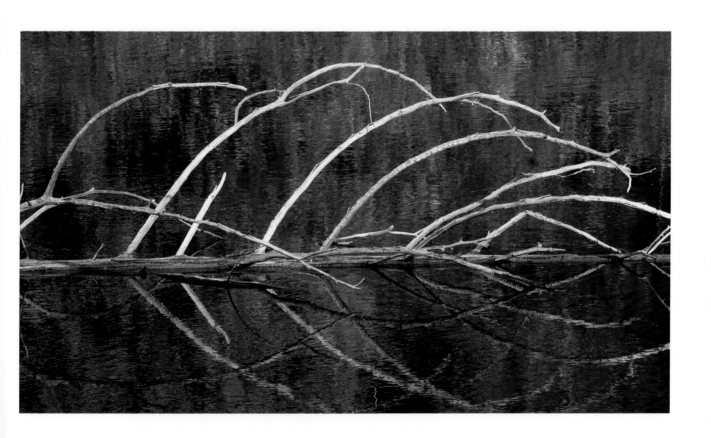

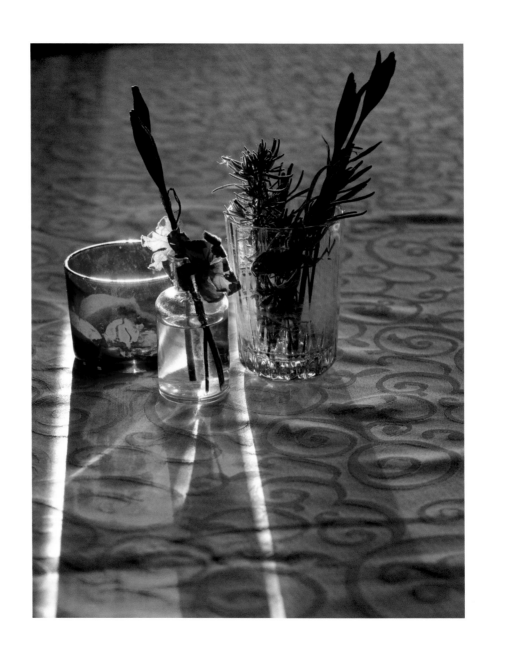

Glass Vase, White Table

When you are that fragile, that wrung thin
(there's been illness, there's been worry, there's been growing old),
when nothing stops winter's light from streaming through,
you'll see the purest, clearest
part of you
cast as amethyst across a drift of snow,
so like the reflection of a glass vase
 upon a clean white cloth.

Not an altar cloth,
it's just a square of cotton
on a kitchen table—
but a table where the souls
of those you love might gather
for one last earthly meal.

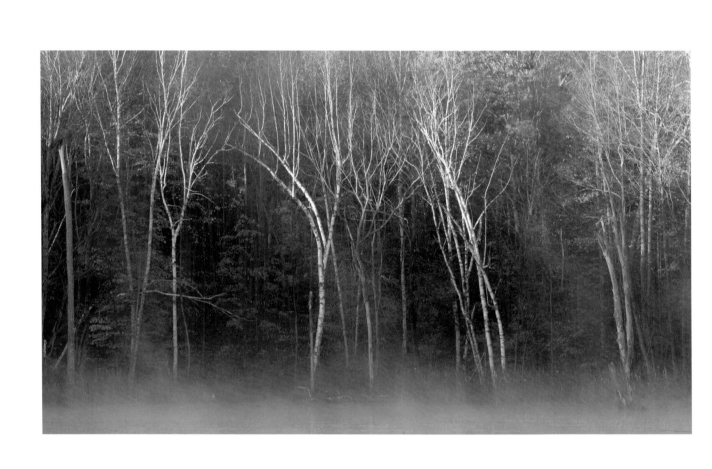

A Small Ambition

To be no more than mist
rising above the rushes,
entering the white
limbs of the trees.

For just one hour
to be a calmness,
a lifting up
minus bones and muscles,

minus memory
and cognition
and your own insistent
longing to last.

The House the Spirit Builds

Its last time on earth
this soul occupied a human. No wonder,
back with us, it longs for a house
with window after window
after window

as if in its return
it will live inside an old one
looking out,
or in a moth, a bluebottle
fly, a pair of glasses
that gawks without eyes
at that slant of sun

sliding through, and in its path,
smaller than fireflies,
the hundreds of motes
that will survive
any fear or flesh or laughter.

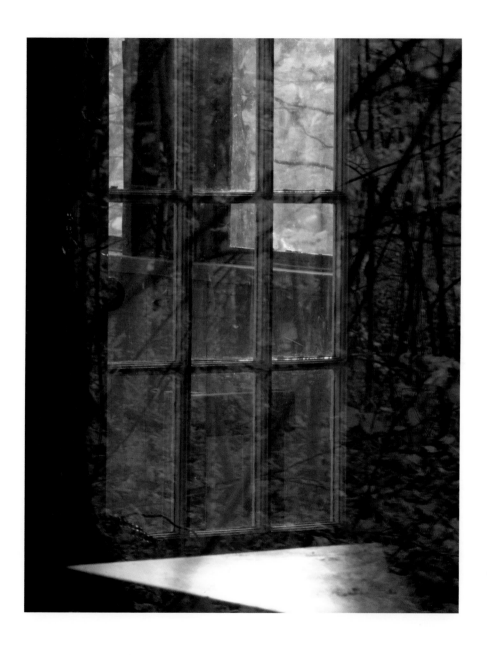

Prayer

Pray for the white-footed mouse, the common
deer mouse, the meadow jumping mouse,
the woodland jumping mouse, the house mouse
who doesn't jump, but pauses on the counter
by the stove to clean his whiskers with a four-toed paw;
you watching, the cat watching too—you have to admire
the rodent's cool, his aplomb, though you don't want him here, pebbling
the bowls, the cutlery drawer, the cookie tins. Nevertheless,
pray to the round-eared, dark-eyed gods of mice. Build for them
near the woodpile a temple of stems, cotton from a pill bottle,
shredded paper for a floor; early drafts of poems, you hear, are best;
on one narrow strip you find *I had to learn a language*
where someone loved me, the words blacked out, barely
legible, discarded. Pray for the mice and the star-nosed mole,
the hairy-tailed mole, the masked shrew, the southern bog lemming,
the meadow vole. This is not to forget the predators who hunt
on wing and paw. This is not to summon hunger into the cave
of their bellies. There is room in your prayer for owls, the barred,
the screech, the great horned; there is room for the turkey vulture
and his naked neck; for the marmot, the coyote, the red fox
the leaves of the maple mimic every fall. You bow, you kneel,
you lie chest-down flat on the ground. Pray for the maple,
the ox-eye daisy, the caddis fly, the wood nettle. Pray,
oh pray, for the snowshoe hare and the little brown bat.